My Heart
Is in the South

SOURCEBOOKS, INC.
NAPERVILLE, ILLINOIS

Published by Sourcebooks, Inc.
P.O. Box 4410, Naperville, Illinois 60567-4410
(630) 961-3900
Fax: (630) 961-2168
www.sourcebooks.com

ISBN-13: 978-1-4022-0816-4
ISBN-10: 1-4022-0816-2

Printed and bound in China
IM 10 9 8 7 6 5 4 3 2

What has always
been clear,
for Southerner and
non-Southerner alike,
is that Dixie is
the most fascinating
part of the country.

—Fred Hobson

Down South
everybody cherishes dreams.
In dreams, this world
and the next
mix like sugar and grits.

—Grandmother Ernestine,

to novelist

Jewell Parker Rhodes

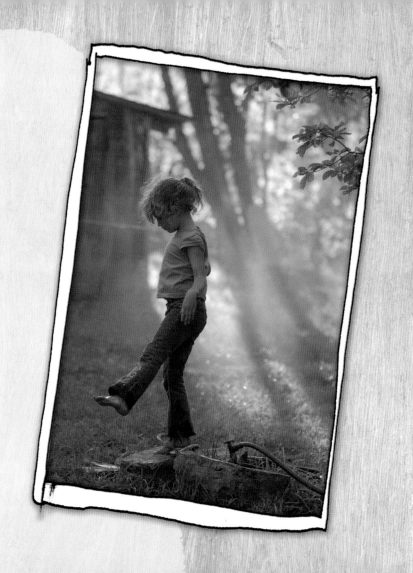

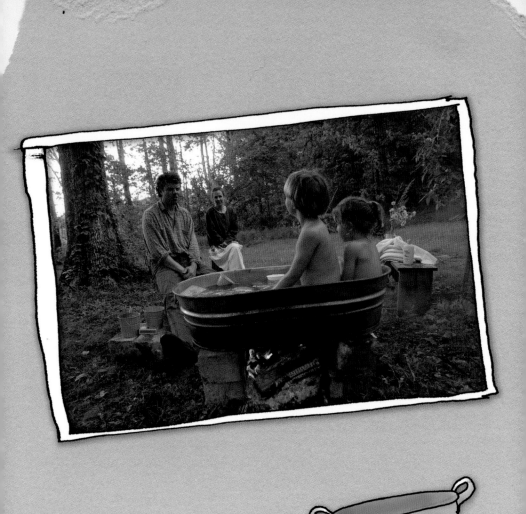

The natural
summer heat...
makes the inside of houses
and offices agreeably
uninviting, if not
actually prohibited
territory.

—Clarence Cason

Southerners are generally polite and unpretentious; perhaps it's too hot to be otherwise.

—Blanche McCrary Boyd

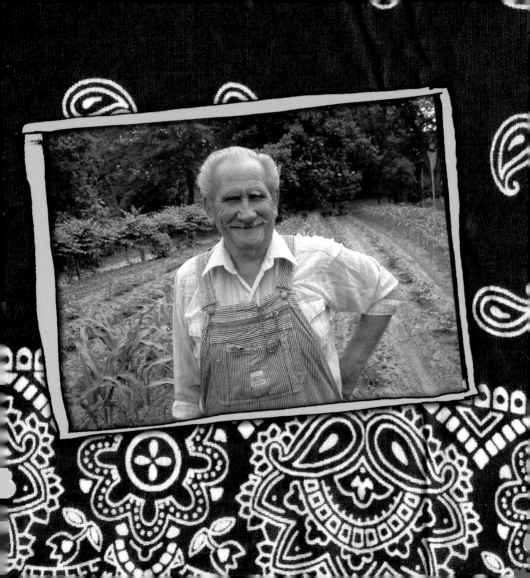

The biggest myth about Southern women is that we are frail types— fainting on our sofas...

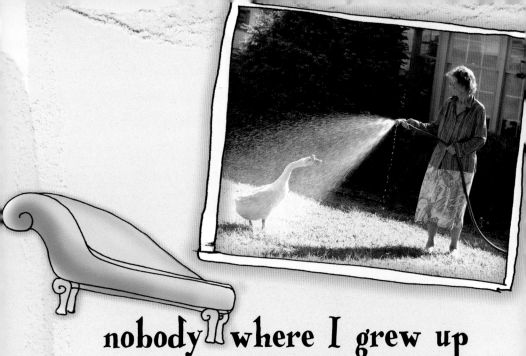

nobody where I grew up
ever acted like that.
We were about as
fragile as coal trucks.

— Lee Smith

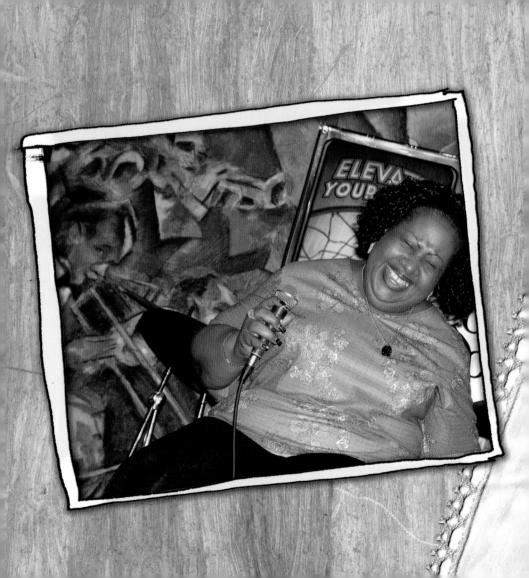

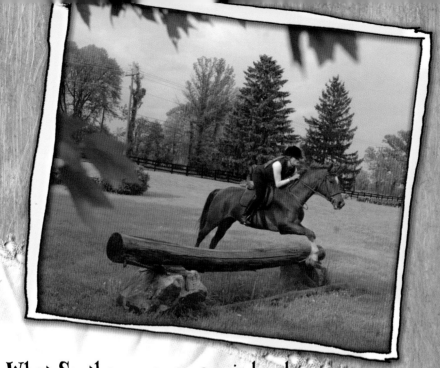

What Southern women are is loyal,
 very sexy, polite to a fault, and
 when necessary, razor-sharp in their wit.
And most importantly, a Southern woman
 (when pushed) will—in every possible
meaning of the phrase—"Kick your ass!"
 —Branford Marsalis

The only thing
that separates
us from the animals
is our ability
to accessorize.

—Clairee Belcher
from Steel Magnolias

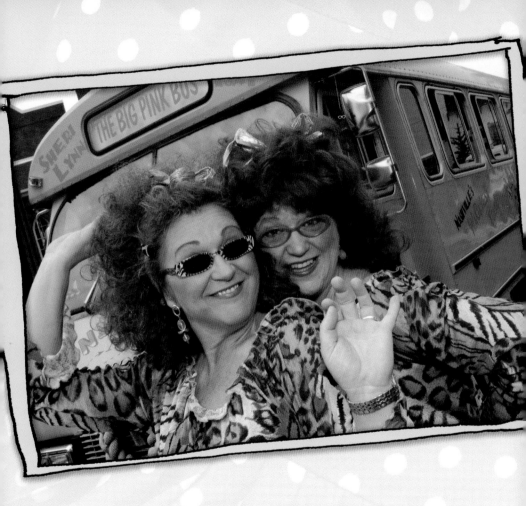

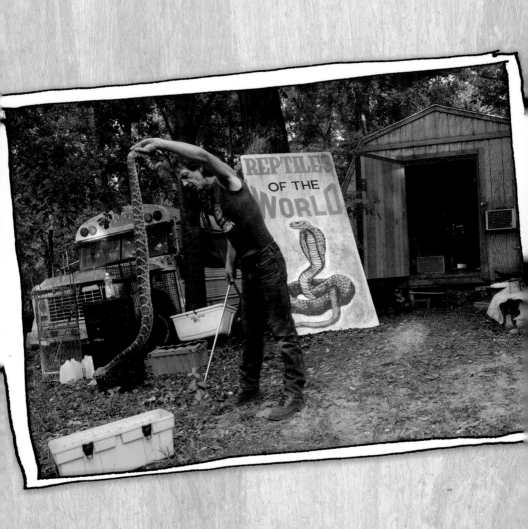

Southerners have a genius for psychological alchemy...If something intolerable simply cannot be changed, driven away, or shot they will not only tolerate it but take pride in it as well.

—Florence King

By contrast with
the Yankee,
the Southerner
never uses one word
when ten or twenty
will do.

—Charles Kuralt

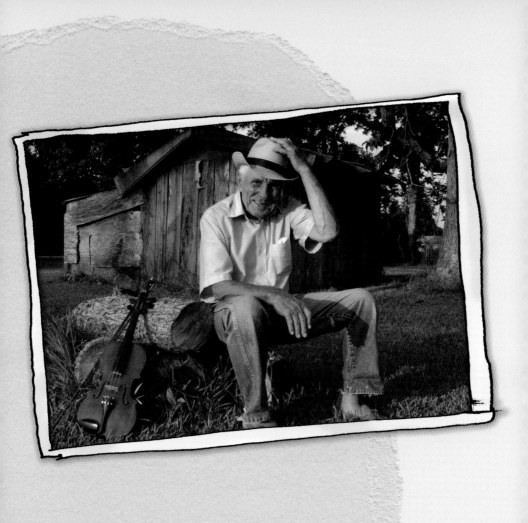

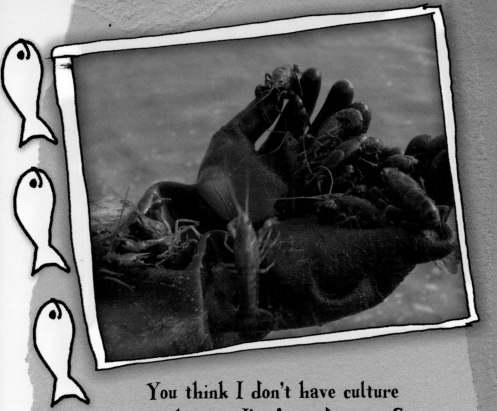

You think I don't have culture
just because I'm from down in Georgia.
Believe me, we've got culture there.
We've always had sushi.
We just called it bait.
—Ben "Cooter" Jones

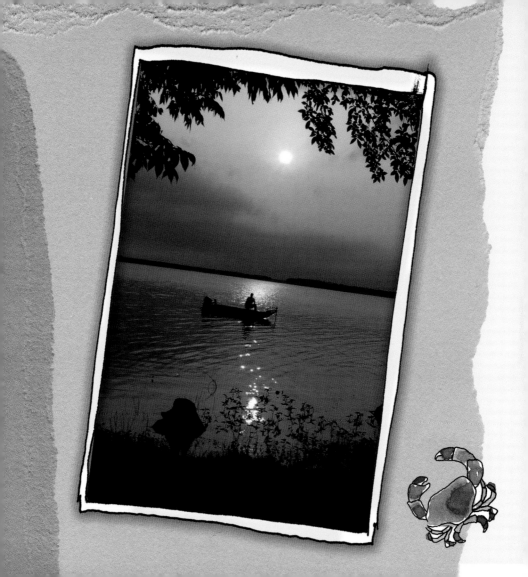

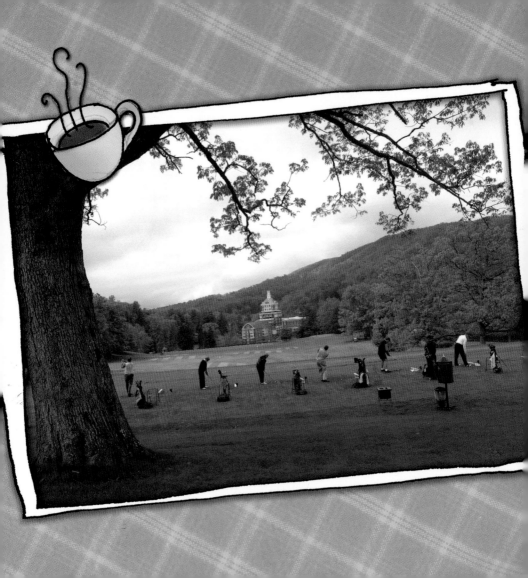

They're Southern people, and if they know you are working at home, they think nothing of walking right in for coffee. But they wouldn't dream of interrupting you at golf.

—Harper Lee

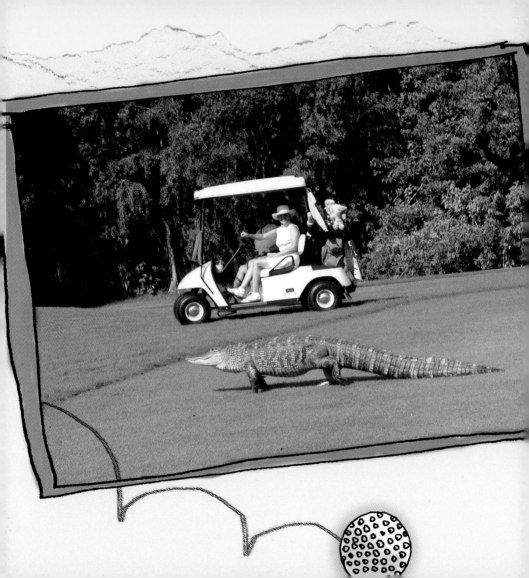

Once when I was
golfing in Georgia
I hooked the ball
into a swamp.
I went in after it
and found an
alligator wearing
a shirt with a picture
of a little golfer on it.

—Buddy Hackett

The Bible Belt likes
its religion the same
as its whisky—
strong, homemade,
and none too subtle.

—Anonymous

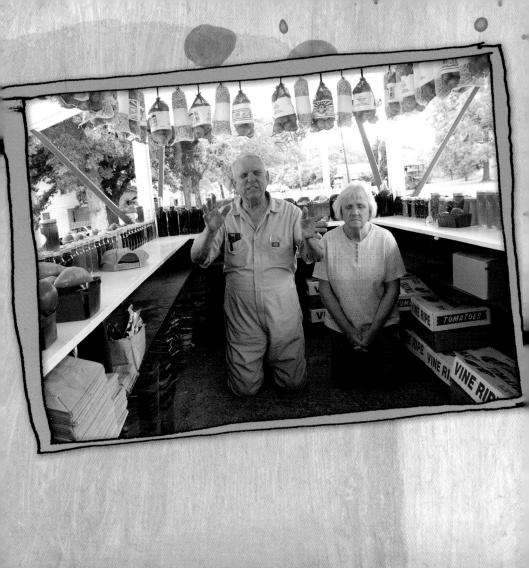

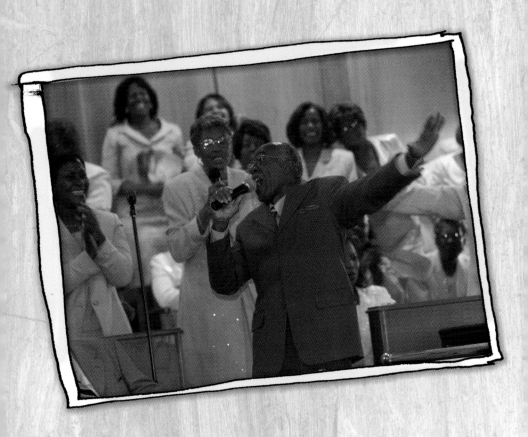

Singing is to preaching
what gravy is to steak.
Gravy is not steak,
but it makes the steak
taste better.

—Reverend Willie Morganfield

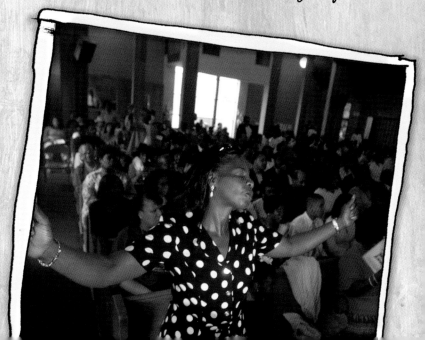

The Bible
tells us to love
our neighbors,
and also to love
our enemies;
probably because
they are generally
the same people.

—G.K. Chesterton

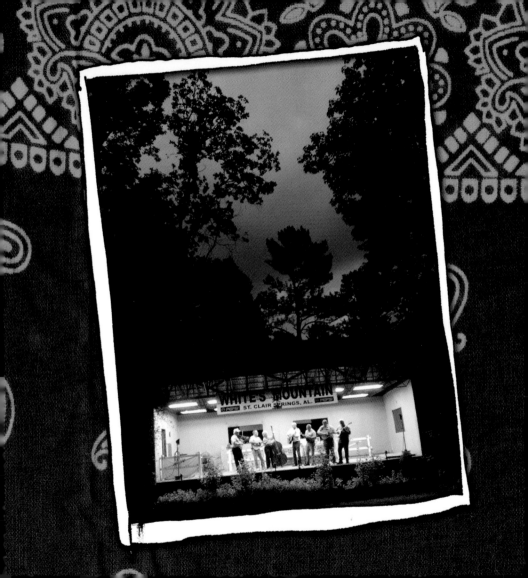

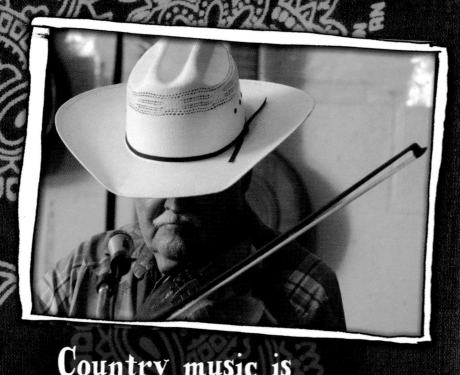

Country music is
three chords and
the truth.

—Harlan Howard

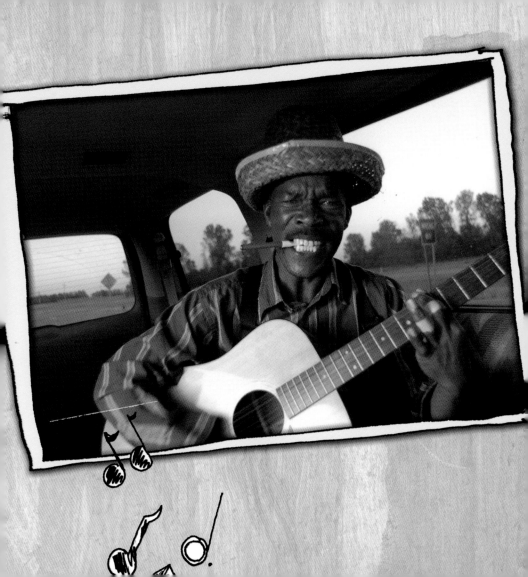

Any problem
you can't solve
 with a good guitar
is either unsolvable,
or isn't a problem.

—Anonymous

Those who danced
were thought to be
quite insane by
those who could not hear
the music.

—Angela Monet

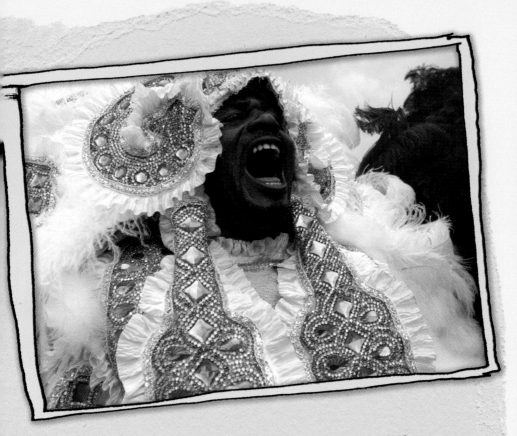

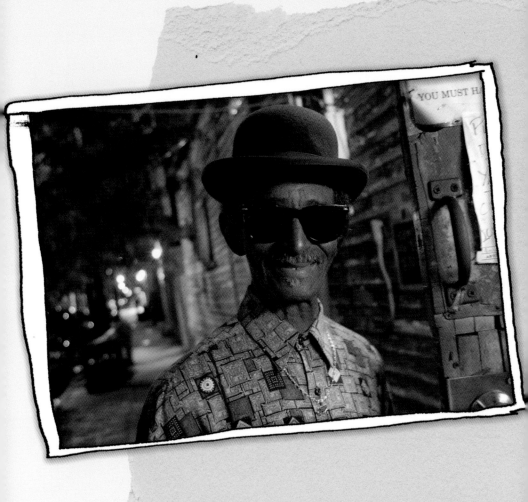

Bluesmen,
 history tells us,
rarely retire.

—Jonathan Miles

Bourbon Street

Once,
during prohibition,
I was forced
to live for days
on nothing but
food and water.

—W.C. Fields

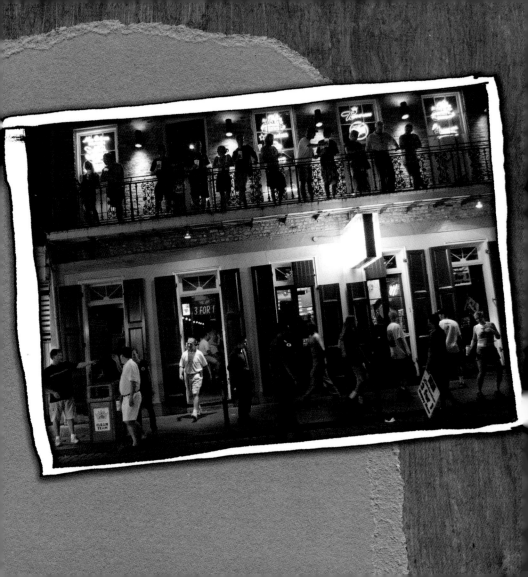

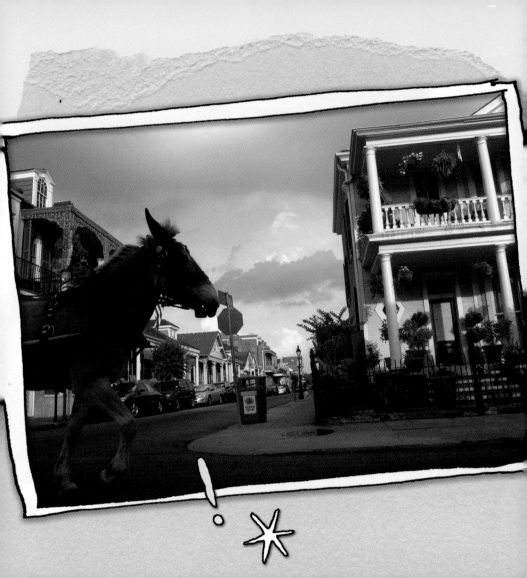

@ * ! I can't imagine driving through [L.A. traffic] every day. Between my home and our office there's one traffic light— and when it's red, I cuss.

—Hartley Peavey

Southerners
can claim kin
with anybody.
It's one of our most
dexterous talents.

—Guy Davenport

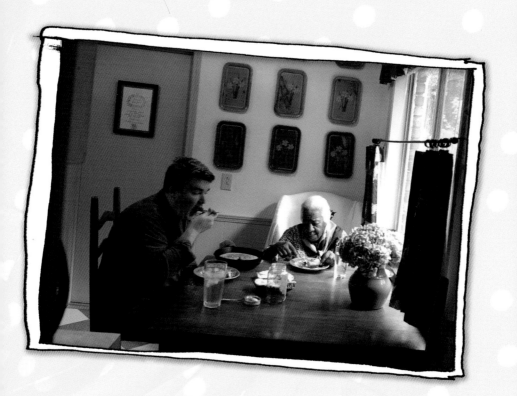

The true Southern watermelon is...chief of this world's luxuries, king by the grace of God over all the fruits of the earth. When one has tasted it, he knows what the angels eat.

—Mark Twain

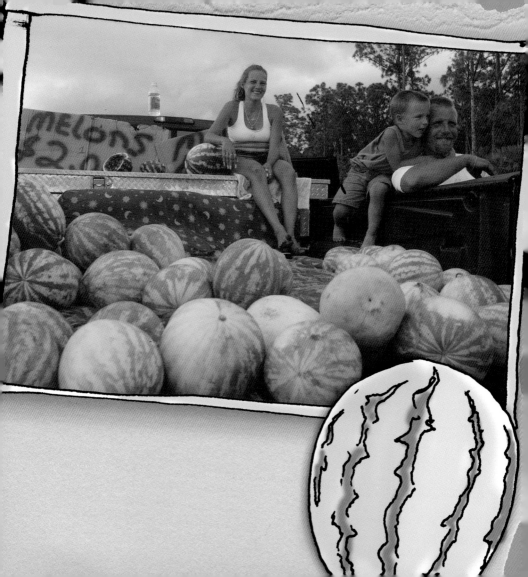

Life is better
than death, I believe,
if only because it is
less boring, and because
it has fresh peaches in it.

—Alice Walker

Why, land is
the only thing in
the world worth
workin' for,
worth fightin' for,
worth dyin' for,
because it's the only
thing that lasts.

—Margaret Mitchell

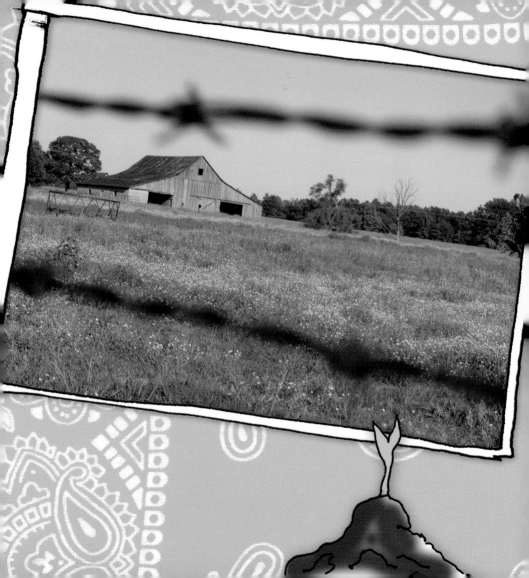

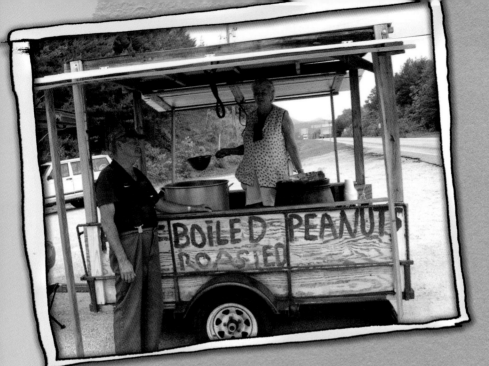

The South may not
always be right, but by God
it's never wrong!

—Brother Dave Gardner

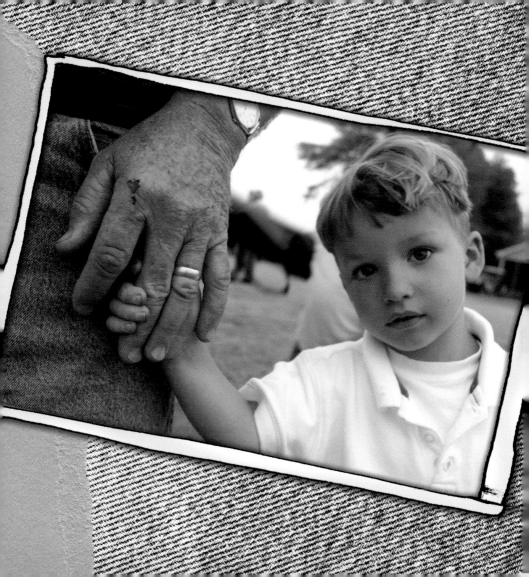

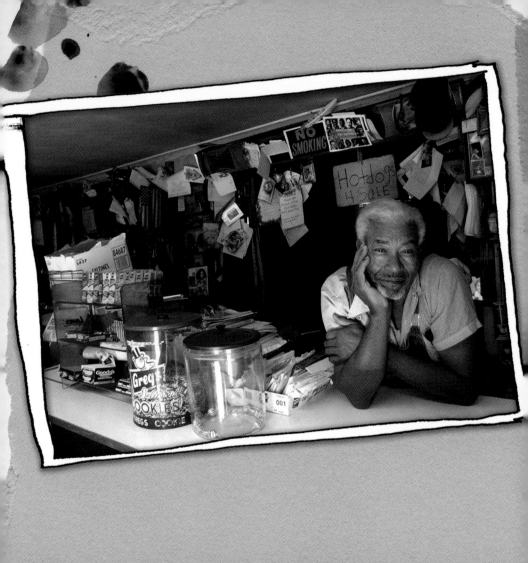

You can't
understand it.
You would have
to be born there.

—William Faulkner

There ain't
nothing from
the outside
that can lick
any of us.

—Margaret Mitchell

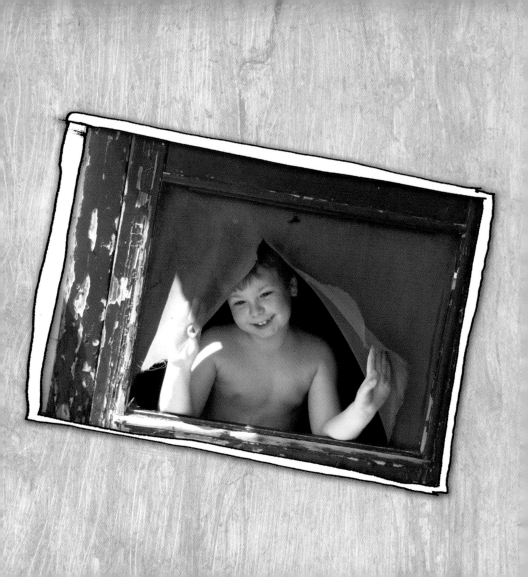

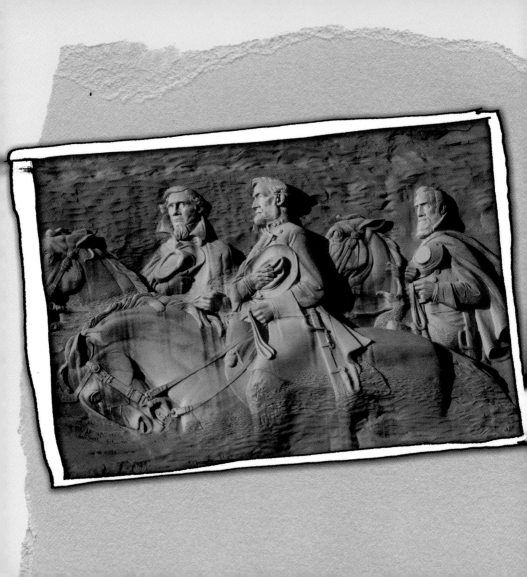

The friend
asked why the Rebel army
had continued to fight
when defeat was certain.
They were simply afraid
to go home and
face their women.

—Gordon Cotton

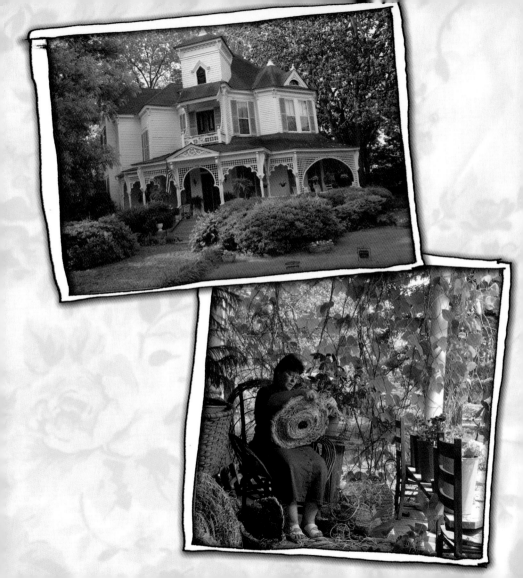

Southerners have been known
to stay over the Fourth [of July]
and not get home before
Thanksgiving. Some old timers
take in overnight guests
and keep them through
three generations.

—Mary Ellen Robinson Snodgrass

It usually
takes **100** years to
make a law, and then,
after it's done
its work, it usually
takes **100** years
to be rid of it.

—Henry Ward Beecher

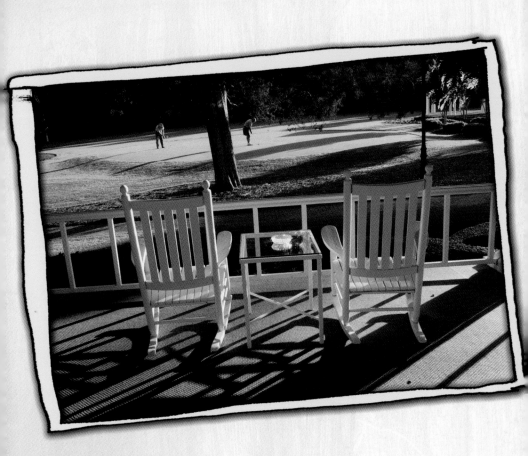

They talk
of the dignity of work.
Bosh.
The dignity is in leisure.

—Herman Melville

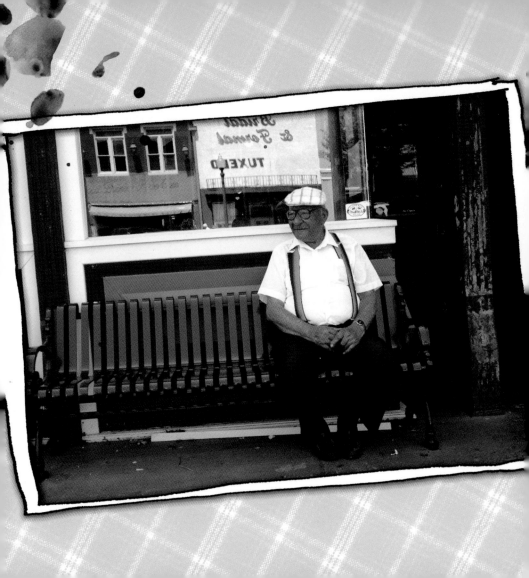

Sometimes I sits
and thinks,
and sometimes
I just sits.

—Satchel Paige

If things get any
better, I may have
to hire someone
to help me enjoy it.

—Southern Saying

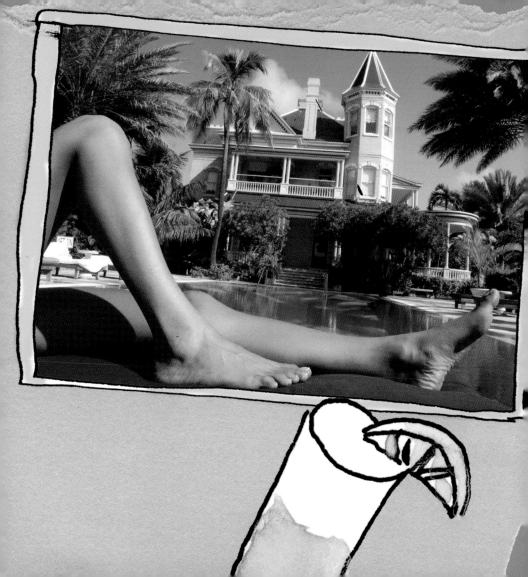

Photography Credits